PROPERTY OF:

DIABLO®

BURNING HELLS

With seas of fire and hosts of the undead, the Burning Hells are the birthplace of Evil. Molten rivers of lava and black stones form ominous pathways throughout the ever-shifting realm. Littered with chilling monsters, the Hells are the dominion of the Great Evils, demons who have corrupted even the realm's architecture. It is a sinister underworld filled with horrors that heroes must face when they journey to slay Diablo—an evil place made almost palpable by the dark and stunning art of Blizzard.

Diablo® is celebrated for its bold designs and vivid worldscapes—a showcase of Blizzard Entertainment's brilliant aesthetic and long-established artistic values. More than a game, it is a world filled with images both sublime and terrifying that push the nefarious boundaries of creativity, beckoning heroes to partake in the eternal conflict between good and evil.

"You shall never wake from this nightmare!"

Diablo

www.blizzard.com • www.diablo.com
Copyright © 2013 Blizzard Entertainment, Inc. All rights reserved.
Blizzard Entertainment and World of Warcraft are trademarks or registered trademarks in the U.S. and/or other countries.
Cover art by Glenn Rane. Interior art by Phroilan Gardner and Peter Lee.

INSIGHTS
INSIGHT EDITIONS
San Rafael, California
www.insighteditions.com

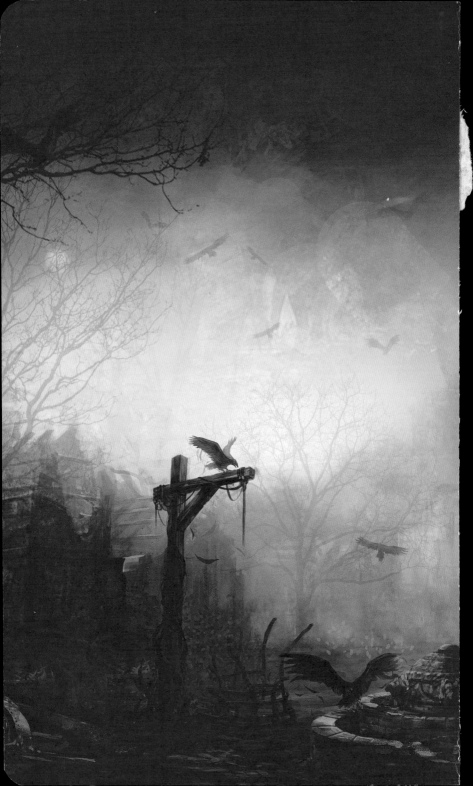